Curious Cats and Kittens

Coloring for Everyone

Skyhorse Publishing

Artwork copyright © 2016:

iStock/Ashwin82 (Intro image, Bastet statue)
iStock/janecat (Intro image, Abyssinian cat)
Wikimedia/Gage Skidmore (Intro image, Grumpy Cat)
Shutterstock/Tanor (Image 1, 2)
Shutterstock/LenLis (Image 3)
Shutterstock/smilewithjul (Image 4)
Shutterstock/paw (Image 5, 7, 12, 19)
Shutterstock/tets (Image 6, 25)
Shutterstock/elvil (Image 8)
Shutterstock/Pim (Image 9)
Shutterstock/AlexTanya (Image 10)
Shutterstock/Baksiabat (Image 11)
Shutterstock/ira_gord (Image 13)
Shutterstock/Apolinarias (Image 14)
Shutterstock/Art-and-Fashion (Image 15, 46)
Shutterstock/Panteleeva Olga (Image 16)
Shutterstock/Mrs. Opossum (Image 17)
Shutterstock/vitarpan (Image 18)
Shutterstock/Shizayats (Image 20)
Shutterstock/Fears (Image 21)
Shutterstock/leffka (Image 22)

Shutterstock/Fairy-N (Image 23)
Shutterstock/MargaritaS (Image 24)
Shutterstock/Ovocheva (Image 26)
Shutterstock/Aniwhite (Image 27)
Shutterstock/Kudryashka (Image 28)
Shutterstock/Mistra (Image 29)
Shutterstock/Marushchak Olha (Image 30)
Shutterstock/kelt-md (Image 31)
Shutterstock/Polina Kralina (Image 32, 33)
Shutterstock/Grechko Vlada (Image 34)
Shutterstock/Khliebina Tetiana (Image 35)
Shutterstock/Nadezhda Molkentin (Image 36, 37)
Shutterstock/mis-Tery (Image 38)
Shutterstock/yusuf doganay (Image 39)
Shutterstock/Marina Zakharova (Image 40)
Shutterstock/Kaliaha Volha (Image 41)
Shutterstock/olga2280 (Image 42)
Shutterstock/Rimma Zaynagova (Image 43)
Shutterstock/fantik57 (Image 44)
Shutterstock/Emila (Image 45)

Skyhorse Publishing books may be purchased in bulk at special discounts for sales promotion, corporate gifts, fund-raising, or educational purposes. Special editions can also be created to specifications. For details, contact the Special Sales Department, Skyhorse Publishing, 307 West 36th Street, 11th Floor, New York, NY 10018 or info@skyhorsepublishing.com.

Skyhorse® and Skyhorse Publishing® are registered trademarks of Skyhorse Publishing, Inc.®, a Delaware corporation.

Visit our website at www.skyhorsepublishing.com.

10 9 8 7 6 5 4 3 2

Library of Congress Cataloging-in-Publication Data is available on file.

Cover design by Jane Sheppard
Cover artwork credit: Shutterstock/Nadezhda Molkentin
Text by Chamois S. Holschuh

Print ISBN: 978-1-5107-0845-7

Printed in China

Curious Cats and Kittens:
Coloring for Everyone

You started coloring and doodling as soon as your fat little baby fingers could grasp a crayon. Maybe you still love to dabble in the arts, maybe you haven't held a colored pencil since your last mandatory art class—whatever your creativity level, it's time to embrace the adult coloring book. That's right! It's not just for kids anymore. Speaking of kids, the reason young'uns are so heartily encouraged to embrace the arts is because using their hands to produce visual images promotes brain development and provides a healthy outlet for emotional buildup—which is a fancy way of saying that art makes you smart and relieves stress. Those are things adults need, too, right? And what better way to exercise and relax your mind than by hanging out with some cool cats!

Here, we present you with a collection of feline designs that will set any cat lover's heart to purring. Cat obsession is nothing new and certainly not unheard of in the worlds of art and culture. Let's review. It's common knowledge that cats were strongly revered in ancient Egypt. They were respected for their role in pest control, keeping pesky rodents—and the diseases they carried—at bay as well as for their sleek beauty. The Egyptians even had a cat goddess, Bastet, who was first regarded as a warrior and later as a protector. Moving south to the Upper Nile region of what is now Eritrea and Ethiopia, this area's historical epithet, Abyssinia, is the namesake of a short-haired cat breed.

In addition to the well-known Egyptian regard for cats, Japanese art, literature, and folklore also hold a special place for cats. Again, it was their useful rodent-hunting skills and beauty that ingratiated them to their

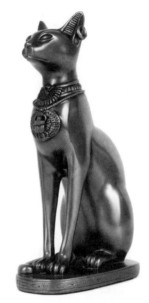
Egyptian Bastet statue

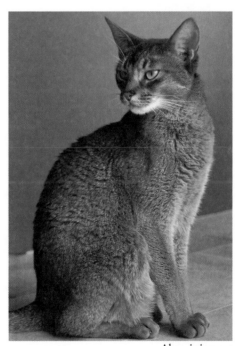
Abyssinian cat

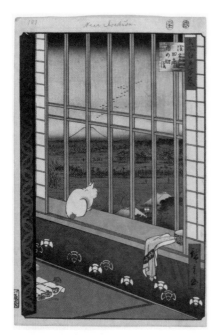

Utagawa Hiroshige's *Asakusa Ricefields and Torinomachi Festival* (c. 1857)

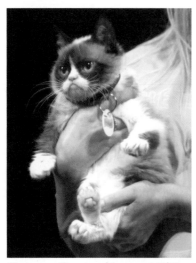

Grumpy Cat speaking at VidCon (2014)

human counterparts, and they were soon household entities, beloved and honored. In older Japanese art, cats are often depicted in the background of everyday activities, napping or bathing, and occasionally featured as the striking, fierce creatures they are. In the modern art and culture of Japan, cats have taken a front row seat. Hello Kitty has captured the hearts of many—and she's not even really a cat. Google it.

Featured heavily in nursery rhyme, the love of cats was instilled in us as children. Remember the tale of the three little kittens who lost their mittens? How about "Pussy cat, pussy cat where have you been?" "Hey diddle, diddle, the cat and the fiddle?" As we grew, so did our love for our feline friends, surrounded as we were by characters and franchises like Garfield, Felix the Cat, and Tom (from *Tom and Jerry*). As we became adept at surfing the web, we found ourselves inundated by cat memes—it all began with the ingenious *I Can Has Cheezburger* website—and curiously talented specimens in YouTube videos. The most famous of all internet felines is, of course, Grumpy Cat, whose interminable frown and scrunched nose have delighted many.

In short, cats dug their claws into our hearts a very long time ago and are still lolling around to bask in our admiration. You've probably heard the saying "Cats were once worshipped by humans . . . and they've never forgotten it." Well, it's time to pay homage. Break out those colored pencils, and demonstrate your love for these furry overlords!

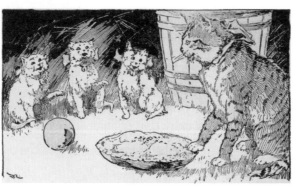

Frederick Richardson's illustration of "The Three Little Kittens" (1911)

1

2

3

4

5

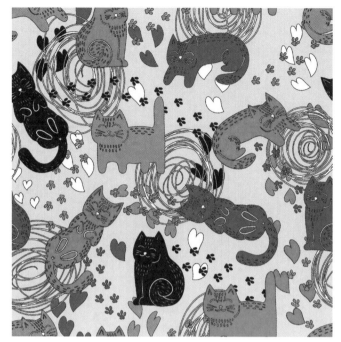

6

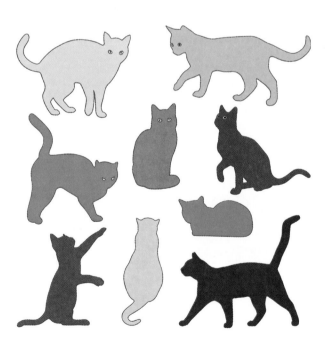

7

8

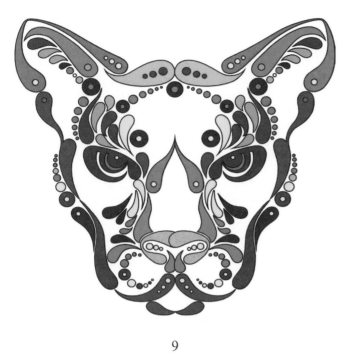

9

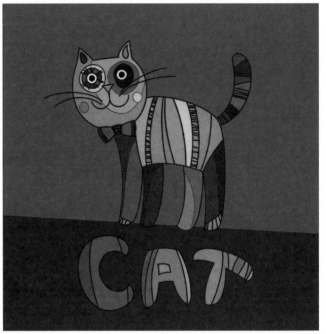

10

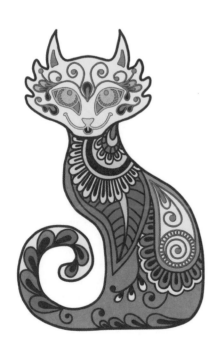

11

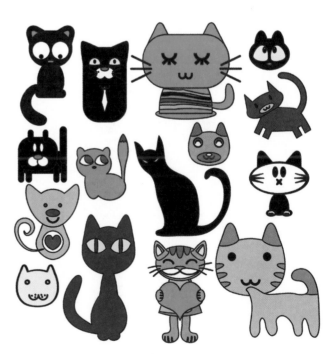

12

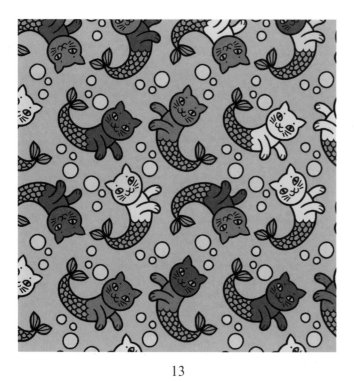

13

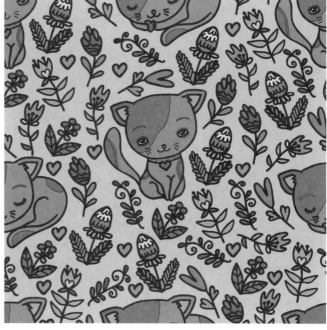

14

15

16

17

18

19

20

21

22

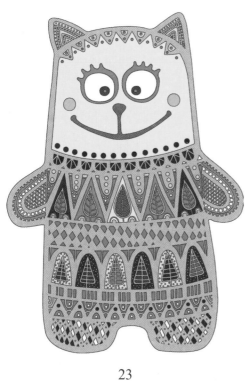

23

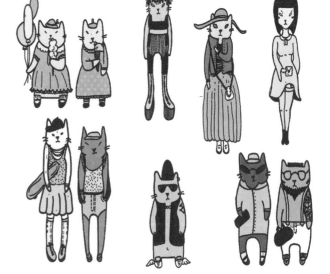

24

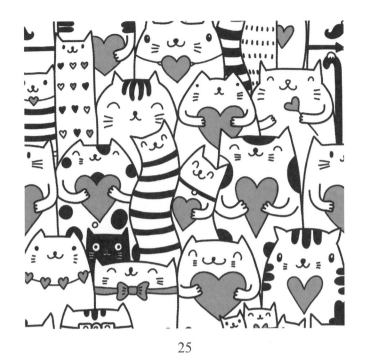

25

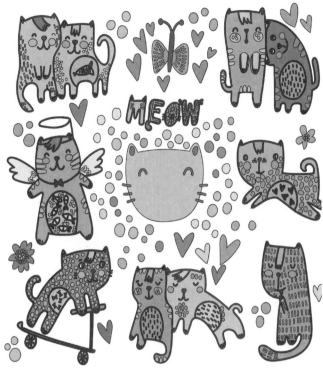

26

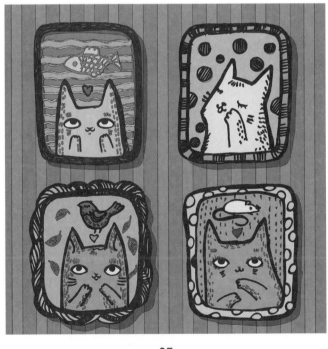

27

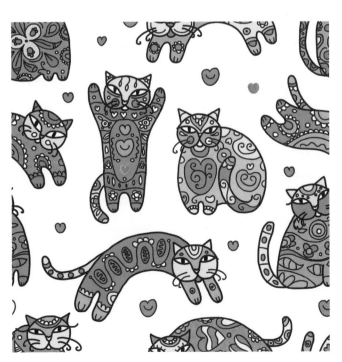

28

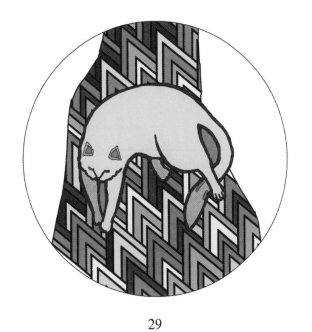

29

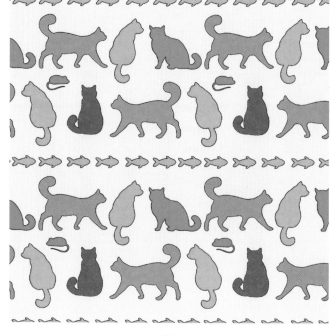

30

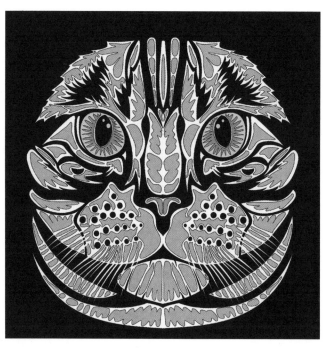

31

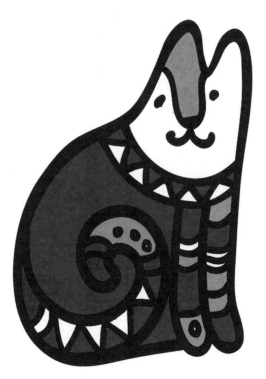

32

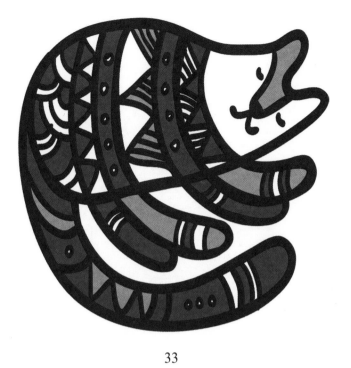

33

34

35

36

37

38

39

40

41

42

43

44

45

46

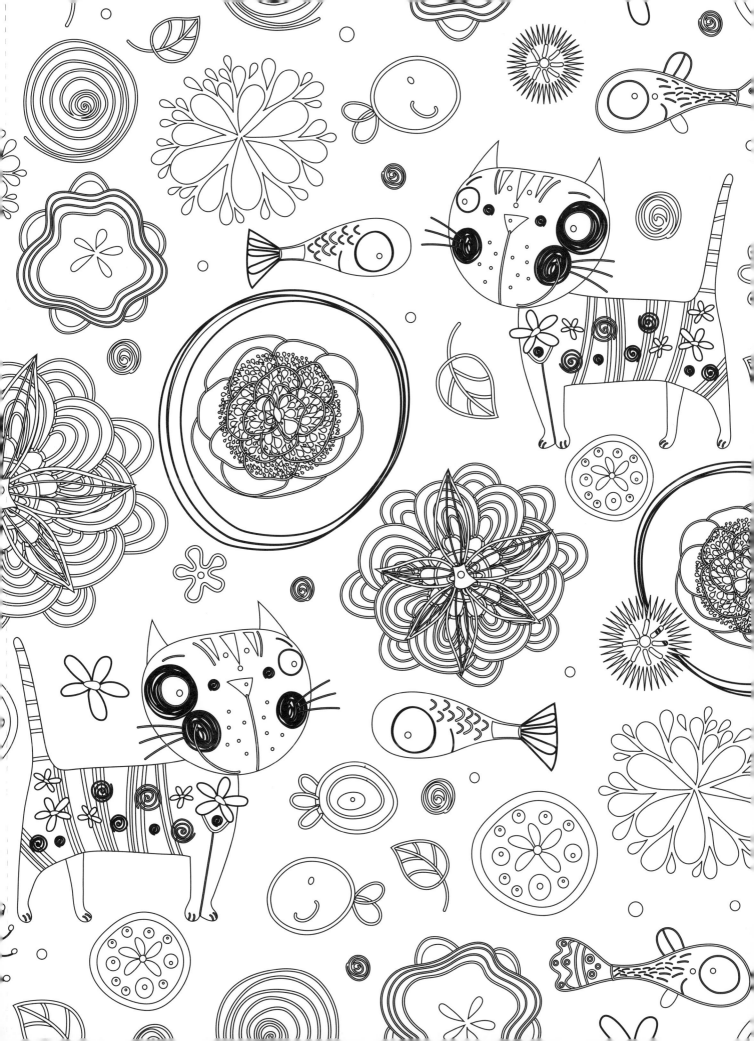

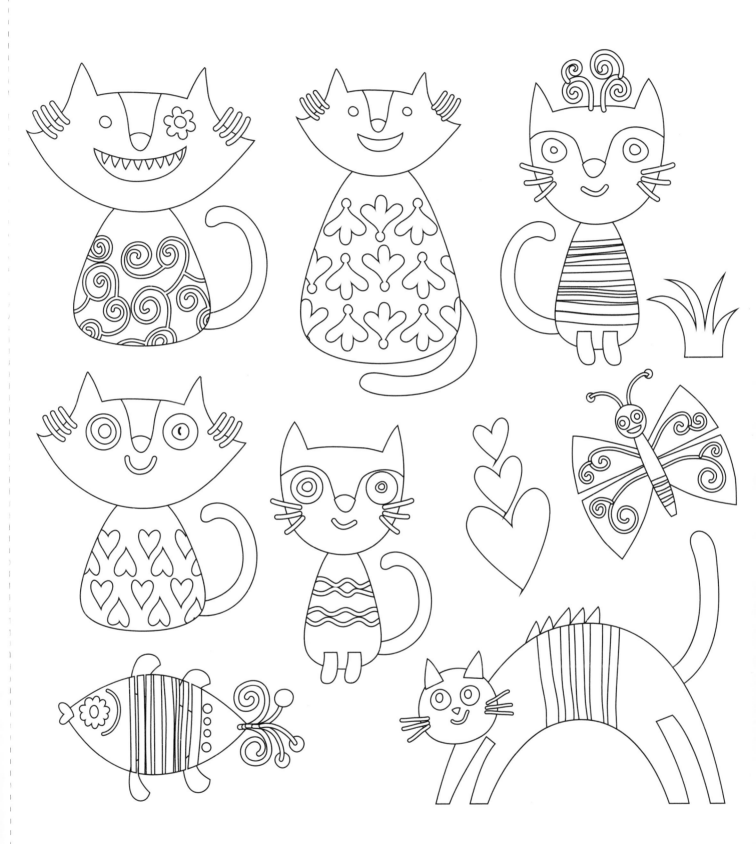

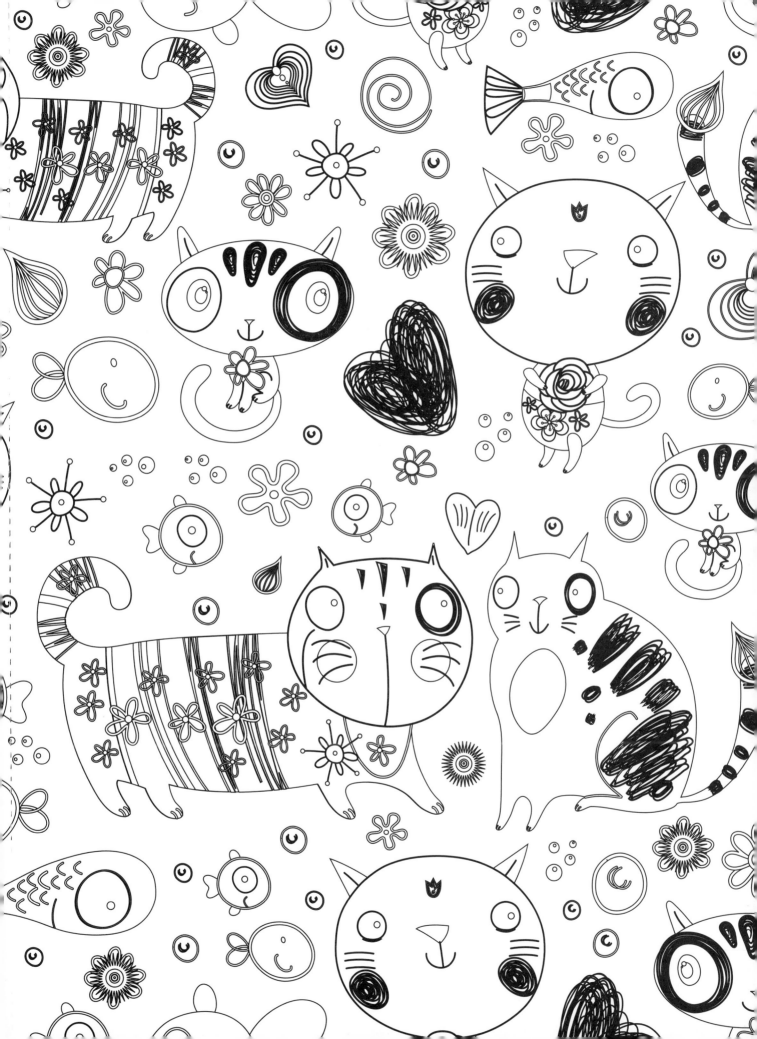

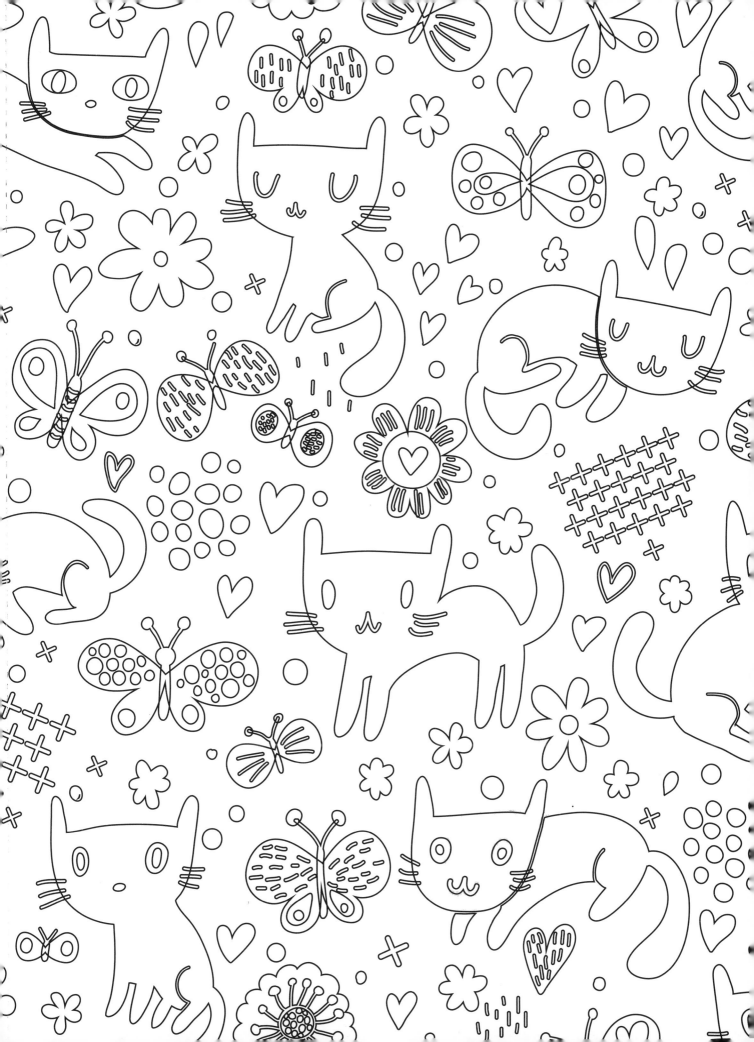

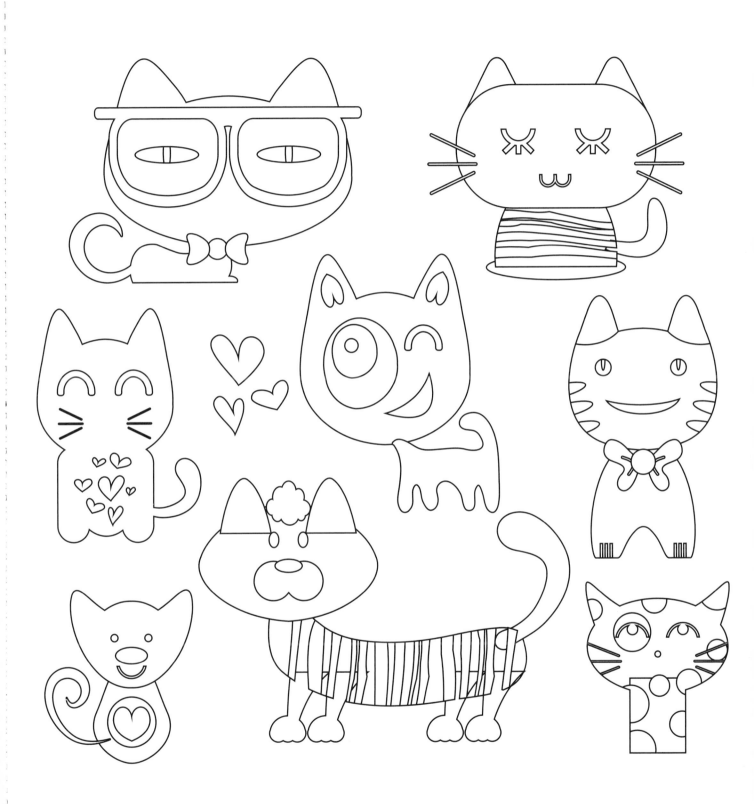

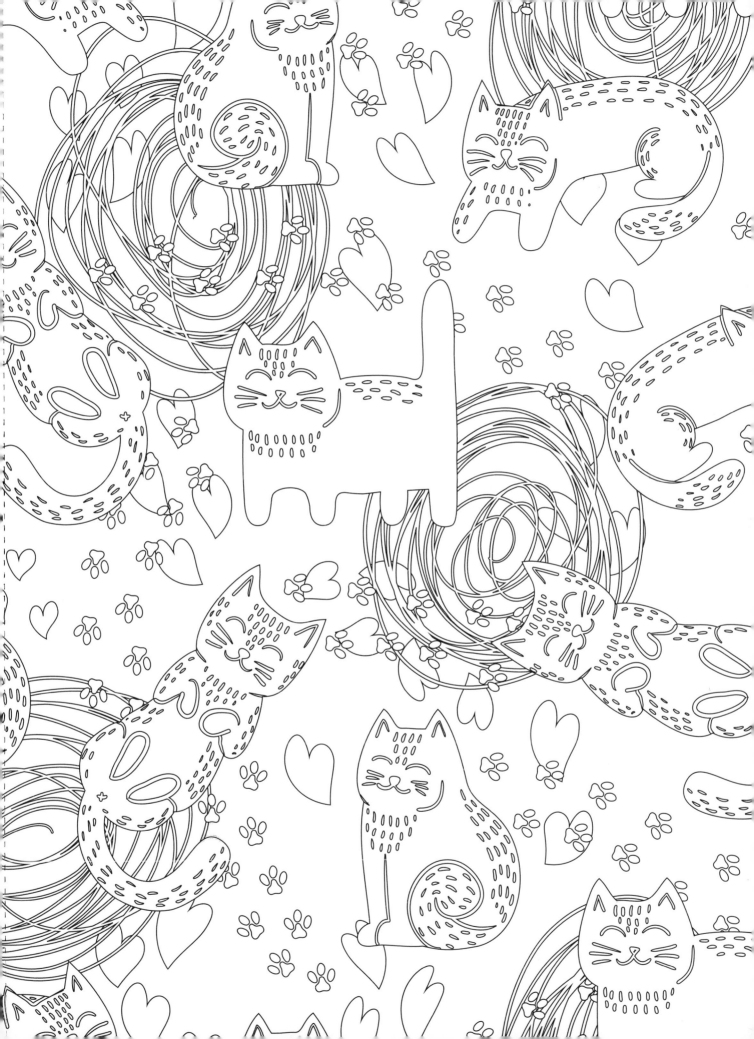

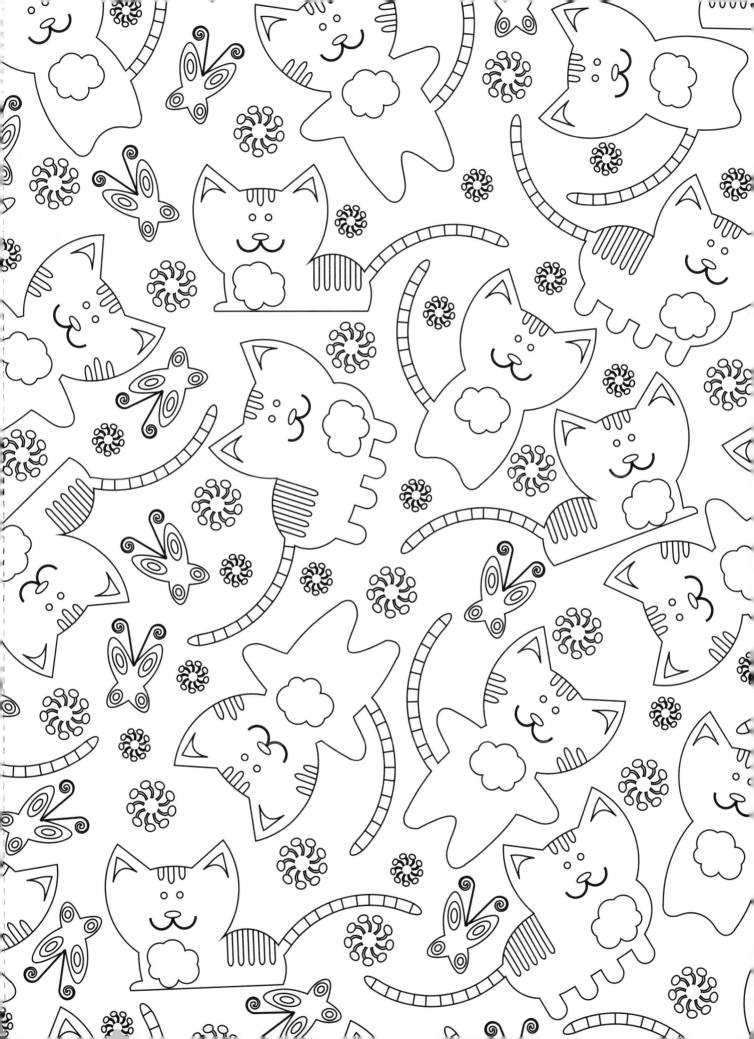

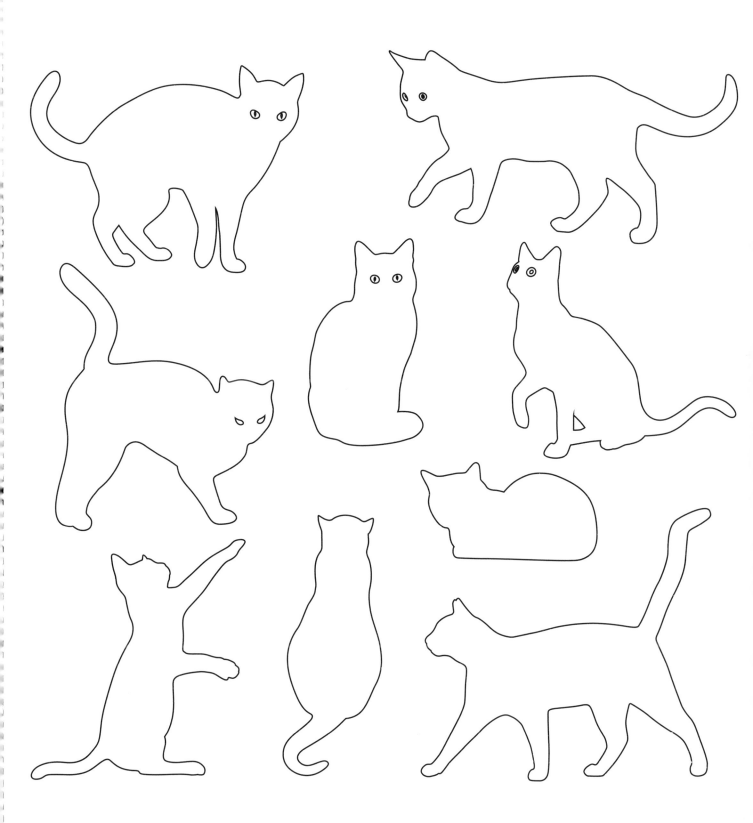

Color Bars

Use these bars to test your coloring medium and palette. Don't be afraid to try unique color combinations!

Color Bars

Color Bars

Also Available from Skyhorse Publishing

Creative Stress Relieving Adult Coloring Book Series

Art Nouveau: Coloring for Artists

Art Nouveau: Coloring for Everyone

Curious Cats and Kittens: Coloring for Artists

Mandalas: Coloring for Artists

Mandalas: Coloring for Everyone

Mehndi: Coloring for Artists

Mehndi: Coloring for Everyone

Nirvana: Coloring for Artists

Nirvana: Coloring for Everyone

Paisleys: Coloring for Artists

Paisleys: Coloring for Everyone

Tapestries, Fabrics, and Quilts: Coloring for Artists

Tapestries, Fabrics, and Quilts: Coloring for Everyone

Whimsical Designs: Coloring for Artists

Whimsical Designs: Coloring for Everyone

Whimsical Woodland Creatures: Coloring for Artists

Whimsical Woodland Creatures: Coloring for Everyone

Zen Patterns and Designs: Coloring for Artists

Zen Patterns and Designs: Coloring for Everyone

The Dynamic Adult Coloring Books

Marty Noble's Sugar Skulls: Coloring for Everyone

Marty Noble's Peaceful World: Coloring for Everyone

The Peaceful Adult Coloring Book Series

Adult Coloring Book: Be Inspired

Adult Coloring Book: De-Stress

Adult Coloring Book: Keep Calm

Adult Coloring Book: Relax

Portable Coloring for Creative Adults

Calming Patterns: Portable Coloring for Creative Adults

Flying Wonders: Portable Coloring for Creative Adults

Natural Wonders: Portable Coloring for Creative Adults

Sea Life: Portable Coloring for Creative Adults